ARTIST'S
LIBRARY
SERIES

Pencil Drawing Step by Step

By Cynthia Knox

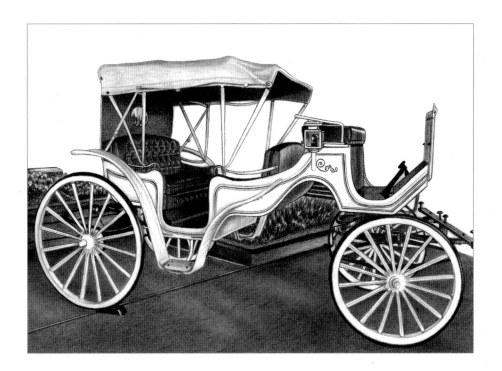

www.walterfoster.com

Publisher: Rebecca J. Razo
Art Director: Shelley Baugh
Project Manager: Elizabeth T. Gilbert
Senior Editor: Stephanie Meissner
Associate Editor: Jennifer Gaudet
Assistant Editor: Janessa Osle
Production Designers: Debbie Aiken, Amanda Tannen
Production Manager: Nicole Szawlowski
Production Coordinator: Lawrence Marquez

www.walterfoster.com
3 Wrigley, Suite A
Irvine, CA 92618

Printed in China.
1 3 5 7 9 10 8 6 4 2
18488

Table of Contents

Introduction

A pencil and a piece of paper are the most basic tools for creating beautiful artwork. Even if you eventually move on to a different medium, you'll find that good fundamental drawing skills are critical. Fortunately, you can learn these skills easily through a few lessons and a lot of practice.

I spent my early years drawing portraits, animals, buildings, and still lifes. I started with a simple 2B pencil and still use one to create most of my graphite artwork. Very little has changed, including my choice of subjects. I continue to get a great deal of satisfaction out of taking a photograph, rendering it on paper, and calling it my own; however, plenty of practice through the years has greatly improved my results. I hope to help you begin a similar journey.

In this book, we will first cover drawing materials and basic techniques. Then we will explore nine different subjects step by step, from sketch to finished work of art. Some subjects are easier than others, but they all involve a variety of techniques, textures, and compositions. I encourage you to flip through the pages and select a project that inspires you. As you draw, feel free to explore your own style and make changes. These projects are meant to motivate you, teach you, and move you closer to your goal of becoming a better artist. I invite you to join me as we create a few great pieces of art together!

Tools & Materials

Graphite pencil artwork requires very few supplies, and fortunately they are fairly inexpensive. Choose professional pencils and paper rather than student-grade materials; they will serve you well by lasting longer and ensuring a higher-quality presentation. In this section, we will discuss the tools and materials necessary to create your own graphite masterpieces.

Pencils

Pencils are labeled based on their lead texture. Hard leads (H) are light in value and great for fine, detailed work, but they are more difficult to erase. Soft leads (B) are darker and wonderful for blending and shading, but they smudge easily. Medium leads (such as HB and F for fine) are somewhere in the middle. There are about 20 pencils available ranging from very hard (9H) to very soft (9B). I stay somewhere in the HB to 6B range and spend most of my time holding a 2B pencil—a nice balance between hard and soft.

I recommend starting with a set of 12 classic wood-encased pencils, which offers a good range to work from as you explore lead hardness; however, I personally prefer mechanical pencils. These instruments lay down graphite consistently and feature a rubberized section at the base to keep fingers from slipping. Because they contain lead refills, no sharpening is necessary, so there is no danger of newly sharpened points scoring the paper. Mechanical pencils come in several widths that accommodate different sizes of lead. I use a mechanical pencil that holds 0.5 millimeter lead, which rarely breaks and feels neither too thin nor too thick in width.

Artist's Tip

My pencil palette usually contains HB lead for outlining a composition; 2B for the majority of the work; and 4B, 5B, and 6B for laying down my darkest values.

Paper

The quality of your paper directly influences the appearance of your artwork. Paper is often categorized by its "tooth," or surface texture. The paper's tooth affects the smoothness of your drawing and the number of graphite layers you can apply before the paper rips. Below are the most common surface types:

- Hot-pressed paper has little to no tooth, resulting in smooth textures.
- Cold-pressed paper has more tooth than hot-pressed paper; its grainy surface yields more textured strokes.
- Rough paper features a coarse tooth that creates rough, broken strokes.

I prefer working on smooth Bristol paper—a thick paper with an extremely smooth surface. This is especially helpful when drawing portraits with smooth skin. I recommend choosing acid-free paper to eliminate future discoloration and deterioration.

Blending Tools

There are several tools you can use to blend graphite for a smooth look. The most popular blenders are blending stumps, tortillons, and chamois cloths. To learn more about blending techniques, see page 9.

Blending Stumps Available in a range of sizes and diameters, blending stumps are handheld tools made of packed paper with a point on each end. They cleanly and consistently blend out graphite and soften the appearance of a drawing.

Tortillons These handheld tools are made of paper rolled to a fine point. They are great for blending graphite evenly and working in small areas.

Chamois Cloths These individually packaged cloths are made of soft leather and sold in square or rectangular shapes. They create very soft, smooth applications of graphite that are particularly useful when rendering skin.

Artist's Tip

Never use your fingers to blend graphite! Oils in your skin will leave behind unattractive markings that cannot be removed.

Erasers

Erasers serve two purposes: to eliminate unwanted graphite or to "draw" within existing graphite. The second use is a common and effective graphite technique (see "Drawing with Erasers" on page 9). I use three eraser types, outlined below.

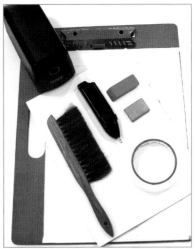

- Usually rectangular in shape, a basic soft rubber eraser is effective even when erasing hard leads. I use it to clean up smudges and finish the outer borders of my work.
- A kneaded eraser comes in a square or rectangle that you can knead into various shapes. You can dab or stroke it to lighten or remove graphite, making it great for establishing subtle textures.
- A battery-operated eraser is perfect for fully removing mistakes—even those in dark graphite. Use it carefully; if it rests too long on the paper, it can drive a hole through the surface.

Sharpeners

You can sharpen pencils with manual, battery-operated, or electric sharpeners. I prefer a good electric sharpener for my wood pencils, but many of my students effectively use battery-operated sharpeners, which are light and portable. Any of these can be purchased at an office supply store.

Drawing Boards

These portable wood and wood-composite boards generally feature a clip and a handle. Before drawing, I use masking or artist's tape to secure a blank piece of smooth Bristol paper to the board surface; then I tape my actual drawing paper on top. The bottom layer of paper provides padding for a smoother application of graphite and ensures that any wood grain or texture from the board doesn't show through my drawing.

Additional Materials

- I keep two drafting brushes nearby as I draw—one to remove wood crumbs from my pencils after sharpening, and the second to sweep away excess graphite from my paper.
- A clean white piece of paper folded under my drawing hand is essential to avoid smudging as I work. Oils from skin can transfer to paper and ruin a drawing. Also, graphite can transfer to the hand as it contacts the artwork. Sometimes graphite adheres to the sheet of paper and lightens the drawing beneath, but I simply touch up my artwork with more graphite.
- Available in a spray can, workable fixative seals and protects finished artwork from smudging and fading. You can also make changes to a drawing after applying it. To use fixative, first perform a spray test. Shake the can several times and spray to make sure it doesn't spit. Then hold the can 6–10 inches away from the artwork and spray evenly. NOTE: The spray is toxic, so don't use it indoors or around people or animals.

Drawing Techniques

There are many different techniques for applying graphite to paper. To determine the best technique for a particular task, ask yourself questions about the subject. Do you want to quickly render a dark, dense background? If so, use crosshatching strokes. Are you drawing wood? Make sure your strokes follow the grain. Are you rendering objects that stand upward, such as a tree or vase? If so, use vertical strokes. Do you want a smooth, evenly toned surface or background? Consider using very small, overlapping circular strokes. Below are examples of the most common graphite techniques.

Horizontal Strokes Apply these directional strokes from left to right and then back again, using a consistent hand motion to achieve smooth lines. Blend with a tortillon.

Vertical Strokes Apply the graphite in long lines, moving from top to bottom. (If you're more comfortable applying horizontal strokes, simply rotate the paper.) Blend with a tortillon.

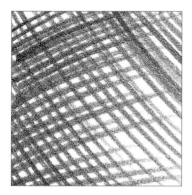

Crosshatching To crosshatch, apply a layer of diagonal parallel strokes; then apply another layer of parallel strokes in the opposite direction. This netlike pattern builds up a smooth density.

Circular Strokes Moving the pencil in a circular motion, create small, tight, and overlapping strokes. Keep them smooth to cover the area with no visible pattern or direction.

Lifting Out Kneaded erasers do much more than simply correct mistakes. Use them to lift graphite to represent strands of hair, fur, whiskers, highlights, and leaf veins. Simply mold the eraser into the shape of a straight edge to pull out streaks, or mold it into a point to create dots.

Blending with Stumps & Tortillons Blending stumps and tortillons soften the look of applied graphite and join strokes together to create a unified appearance. I use these tools often for general blending, rubbing the points along the paper. The softer leads blend nicely, such as those in the "B" range—especially the higher numbers. (A 6B pencil is my favorite for smooth, dark tones.)

Blending with a Chamois Cloth The chamois is great for achieving the smoothest blends possible. I use them when rendering skin tones. Simply fold a small section of the cloth into a flat "point" and gently rub the area to be blended. Because they pick up more graphite than stumps or tortillons, you may need to follow with additional layers of tone.

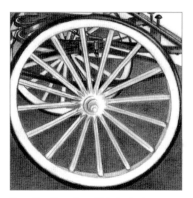

Negative Drawing This technique involves defining your subject by drawing the area around it rather than the subject itself. For example, to render a white wheel with white spokes, I draw the areas in the background that are seen through the spokes. When complete, the white spokes are easily visible although I didn't directly draw them or shade them in.

Artist's Tip

Once a stump or tortillon has been dirtied from blending, you can use it to add light touches of graphite to the parts of your drawing where pencil application would look too harsh.

Value

Value refers to the shades of light and dark that exist in a composition. Graphite can produce every value from light gray to black, depending on the pencil choice and the amount of pressure applied. The "H" and "F" pencils lend themselves to lighter values, and the "B" pencils are capable of creating much darker values. Value scales, such as the one shown below, help us choose the right pencils and pressure to match the drawing to a reference photo.

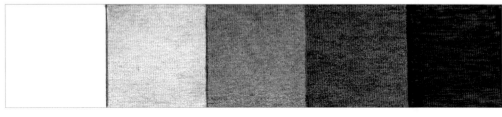

| White of the paper | HB lead | 2B lead | 4B lead | 6B lead |

Artist's Tip

When drawing from color photos, it is helpful to print a computer-generated copy in grayscale. This helps us see the positions of the shadows, midtones, and highlights.

Shading

When an object is illuminated, its form will be defined by five elements of shading visible to our eye. These elements range from full light, which is the brightest area, to the cast shadow, which is often the darkest. Once you blend these values together, the subject becomes smooth and realistic.

A: Full light, referred to as the "highlight," is generally left as the white of the paper. This area is where the light shines directly on the object.

B: Reflected light is the subtle area of light along the shadowed side of an object, between the core shadow and the object's edge. It is produced by the reflection from the adjacent surface or other objects in the composition.

C: Halftone represents the midtone area of the object, which is a value between the highlight and the core shadow. It is usually medium-gray and represents the true color, or "local color," of the object.

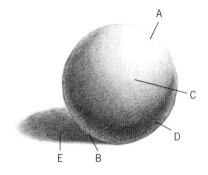

D: The shadow edge, or "core shadow," refers not to the object's edge but to the dark area of the object that is receding from the light source. It is the darkest value on the object itself.

E: The cast shadow is cast by the object onto a nearby surface. It is often the darkest value of the composition, yet becomes slightly lighter in value as it extends away from the object.

10

Lighting

Lighting is critical to the success of a composition. It illuminates the forms, determines the pattern of values, and influences the mood. Photography books are excellent resources for learning more about lighting, and using your camera at different times of day is a good exercise in understanding its importance. My experience is primarily with outdoor light. I love to experiment with its changing nature and observe how it affects a photograph and, ultimately, my drawing. Below are several photos taken with different lighting styles. I encourage you to explore various light sources on your own and think about how they will affect your artwork.

Frontal or Direct Lighting This light hits a subject straight on, completely illuminating the form.

Sidelighting The source for this lighting is at the side of the subject, which creates a three-dimensional appearance with very interesting highlights and cast shadows.

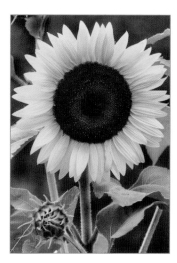

Diffused Lighting This soft lighting is often present on cloudy days or in the shadows of trees or buildings. Colors tend to be more saturated under diffused lighting because they are not bleached out by sunlight.

Backlighting The light source in this case lies behind the subject, which can produce spectacular, glowing effects. We often see silhouettes backlit for dramatic presentation.

Sketching & Transferring

There are many options available to transfer your subject image onto drawing paper. During my beginning years as an artist, I always used the freehand technique. Usually my finished work was okay, but I often had trouble with correct proportions. This led me to the grid method, which is a wonderful way to get proportions spot on. For several years this was all I used. Now I realize the value of using the projector method, which is quick, easy, and probably the best way to achieve perfect proportions.

Freehand with Transfer Paper

On a sheet of thin drawing or tracing paper, sketch out your composition until you are satisfied. Take a piece of transfer paper (sold in art stores) and tape it over the white paper surface you have chosen for your final drawing. There is a coating of graphite on the bottom of the transfer paper. Tape your drawing or tracing paper over the transfer paper. Using a ballpoint pen or stylus, impress the outlines of your drawing with medium pressure. Raise both papers, and you will see the graphite image on your final white paper. Erase the transferred graphite lines if needed as you develop the drawing. Of course, you can always freehand your composition directly onto the final paper. Sketch lightly and erase well.

Grid Method

This method enables you to sketch out your drawing in small segments using one-inch squares. First photocopy your photo and draw a grid of one-inch squares over the photocopy with a pen and ruler. Then very lightly draw the same grid of one-inch squares with a graphite pencil onto your final drawing paper. Starting from left to right, draw what you see in each square. Connect your composition from box to box until it is done. Erase all your grid lines.

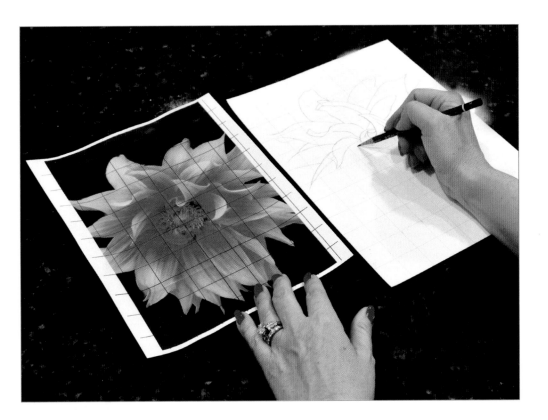

Projector Method

Secure your projector to a countertop and plug it in. Tape your photo inside its top. The photo reflects off a lighted mirror, through a lens, and onto your final paper. Trace the basic outlines of the photo onto your drawing paper. Once the sketch is on paper, you can then focus on creating a perfectly proportioned piece as you refine lines, add detail, and build up tone.

Pear Still Life

Dramatic lighting is an effective tool for creating contrast in a graphite drawing. Deep, dark shadows and extreme highlights attract the eye and create interesting shapes that lead the viewer into and around a composition. This project is a simple setup featuring two pears on a wood cutting board. The directional lighting comes from the upper right and slightly behind the pears, creating strong highlights and form shadows that give the scene a three-dimensional quality. As you draw, avoid simply bordering the pears with a heavy outline. Instead, use soft, blended tones—the lights, midtones, and shadows—to build and define the forms. Follow this simplified process: Lay down an initial layer of graphite, build up the dark tones, blend with a tortillon, and use a kneaded eraser to lift out highlights. The results can be strikingly realistic.

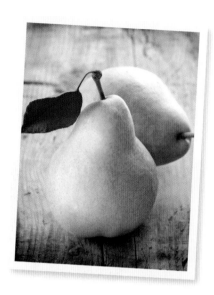

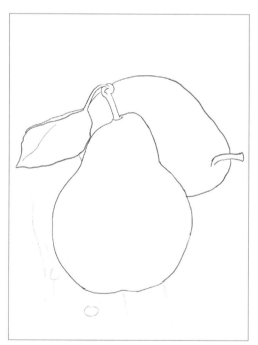

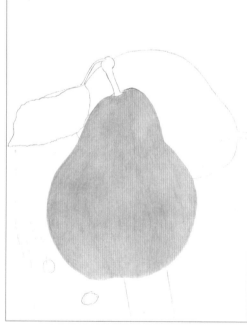

Step 1 Using a 2B pencil, I sketch the outlines of the two pears, the leaf, and a few lines from the wood cutting board onto smooth Bristol paper. This example shows dark lines so you can easily see my composition, but remember to keep your own sketch lines light.

Step 2 I establish an overall foundation for the nearest pear by applying two light layers of 2B graphite. I keep my strokes continuous and soft. Then I blend my strokes with a tortillon followed by a chamois cloth using a firm, circular motion, which creates a smooth look.

14

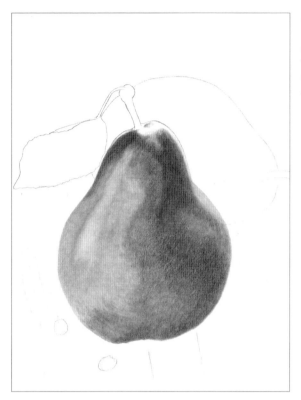

Step 3 Beginning at the top of the pear and moving downward, I lay in the shadowed areas using my 2B pencil and blend with a tortillon. I then block in the most obvious dark shapes using a 4B pencil and blend again with my tortillon.

Step 4 I smooth out the pear by blending with a chamois cloth using heavy pressure. Then, using my kneaded eraser, I lighten the highlighted areas and remove any smudges or strokes that extend outside the pear. I finish this pear by adding a speckled texture using a 2B pencil in the lighter areas and a 4B pencil in the shadows. Next I begin the distant pear with a layer of 2B followed by 7B in the darkest areas. I leave the highlighted area alone for now.

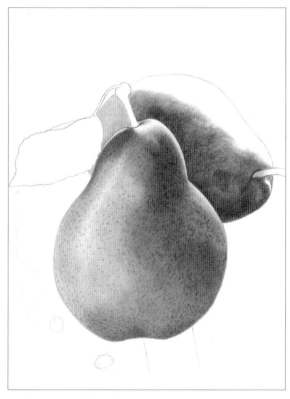

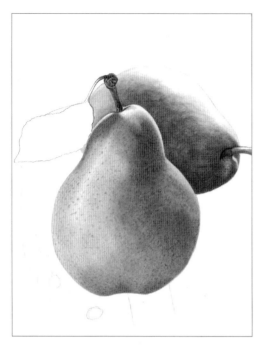

Step 5 I blend the distant pear extensively using a tortillon for the dark areas and a chamois to move graphite into the large highlight, creating a smooth transition. I add a mottled look to the distant pear by dabbing lightly with a kneaded eraser, subtly varying the tone. Next I complete the stems using a 2B pencil for the foundation, switching to 4B and 7B for the midtones and shadows, respectively.

Artist's Tip

Using a "dirty" tortillon rather than a pencil, you can lay in beautiful shading as well as blurred shapes and lines.

Step 6 I begin layering the leaf with a 2B pencil. For the dark upper section, I apply a layer of 4B graphite over the initial 2B layer and add distinct lines to suggest dark leaf veins. For the lower part of the leaf, I add a coat of 4B graphite and keep a few sections light. Then I add tone to the cutting board by blocking in the darks with a 2B pencil followed by a 4B pencil. I layer the shadowed area below the nearest pear with a second coat of 4B.

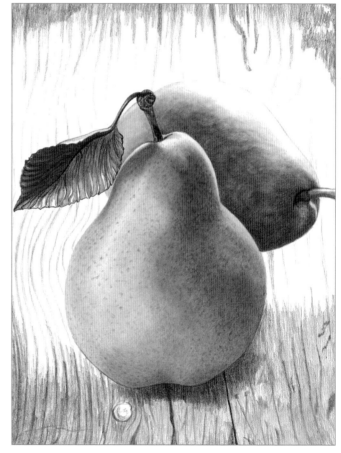

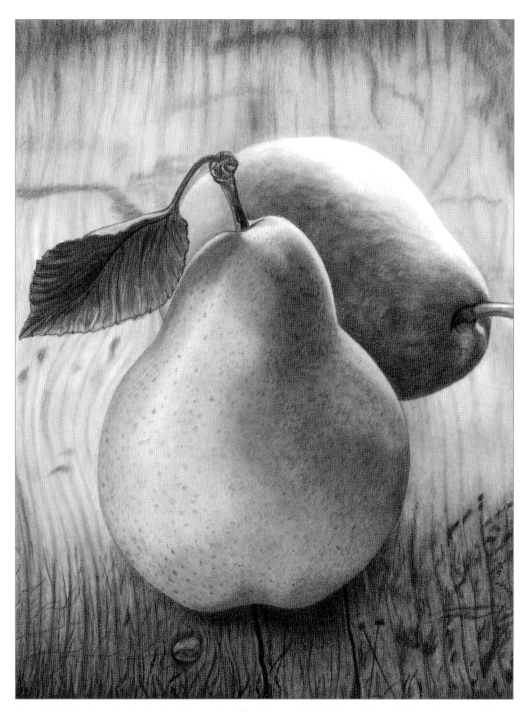

Step 7 This final step includes blending and building the wood detail. I use 4B and 7B pencils to establish the dark areas surrounding the pears. I use a tortillon and a chamois for extensive blending, followed by several applications of graphite to rebuild tone where necessary. This step takes the most amount of time. I then use a 4B pencil to draw in all of the wood grain, including the myriad fine lines at the bottom. I blend the dark areas of the leaf again and lift out some highlights with the edge of a kneaded eraser. After blending all of my edges and cleaning up the drawing, I spray it with workable fixative.

Lion Cub Portrait

Animal fur can be a challenge to draw. Moving in many different directions, fur can be curly and short, wavy and long, or spiky and stiff. However, drawing believable fur is not as daunting as it may seem if you follow a simplified process. For this lion cub portrait I create my initial sketch, lay in the dark areas and blend, lay in the midtones and blend, and then pull out individual strands of light fur with the edge of a kneaded eraser.

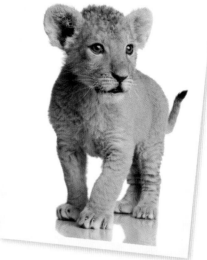

◄ **Step 1** I sketch the outline and main features of the lion cub with an F pencil. I keep my outlines loose and wavy so they won't stand out against the fur at a later stage.

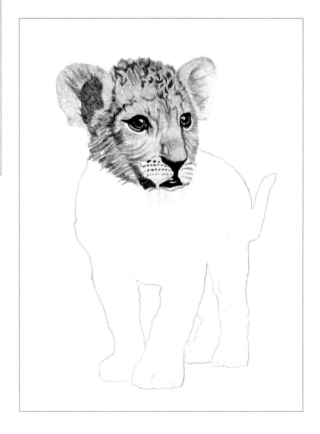

Step 2 I use a 2B pencil to block in and blend the darkest areas of the cub's head. Then I use the same pencil to add a lighter layer of graphite for the midtone, stroking and blending in the general direction of fur growth. With my left finger on the photo as a guide, I use my right hand to draw the light and dark shapes of the eyes carefully and methodically, as they are the most significant feature of the piece. I blacken the exterior rims and pupils while leaving the highlights untouched. I also add radial lines within the iris and smooth them over with another light layer of graphite.

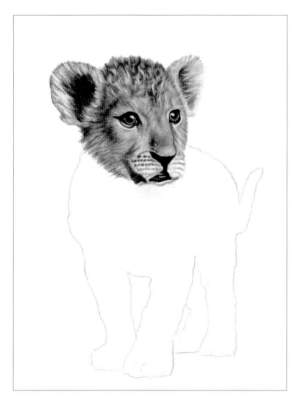

Step 3 To smooth and soften the fur, I blend it with a tortillon and follow up with several additional layers of 2B pencil over the darkest areas. I form a straight edge with my kneaded eraser and pull out streaks of light fur using quick strokes. I continue blending and erasing throughout the entire head, including the cheek and mouth areas.

Artist's Tip
The tortillon is as important as the pencil when creating a graphite piece. I often use a darkened tortillon point to draw soft areas that a pencil might render too harshly.

Step 4 I apply extremely dark tone to the upper left section of the cub's neck using a 2B pencil and firm pressure, which creates a dynamic contrast with the light muzzle. Then I lay in more dark areas down the left side of the cub's chest, blending them with a tortillon as I progress. I use a much lighter touch to stroke in the fur beneath the cub's chin, preserving the white fur. I use the tortillon to blend and pull out random streaks of light fur. Once I've established the upper body, I use the straight edge of a kneaded eraser to pull out whiskers.

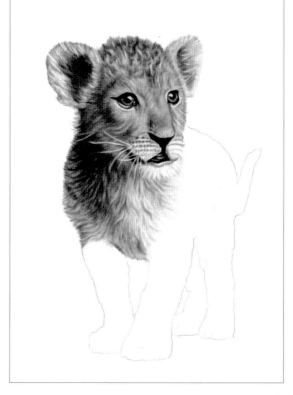

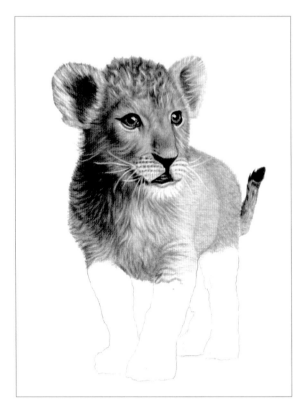

Step 5 I add a few dots on the right side of the cub's mouth for symmetry and blend them with a tortillon. Moving back to the chest, I develop the fur with short, soft, and light strokes using a 2B pencil, progressing from left to right. I use the tortillon to smudge down the two curved vertical lines of the belly, blending the fur against the direction of the pencil strokes. I use a kneaded eraser to pull out random streaks of fur and whiskers on the right side. For the tail, I use a 2B pencil and heavy pressure to define the darkest areas; then I lightly blend with the tortillon in the direction of fur growth.

Step 6 I take some artistic liberties with the reference photo because I want to give the appearance of a natural environment. I loosely sketch blades of grass around the feet. Beginning with the cub's front right leg, I lay in the darks using firm pressure and then add the lighter fur with soft, gentle strokes. I blend and pull out individual streaks of fur using the edge of my kneaded eraser. I repeat this process for the front left leg, leaving the claws mostly white.

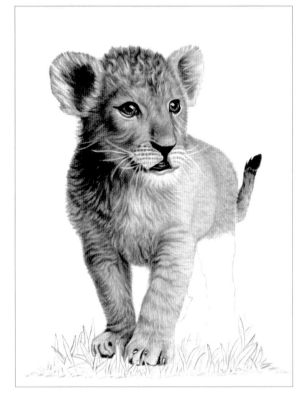

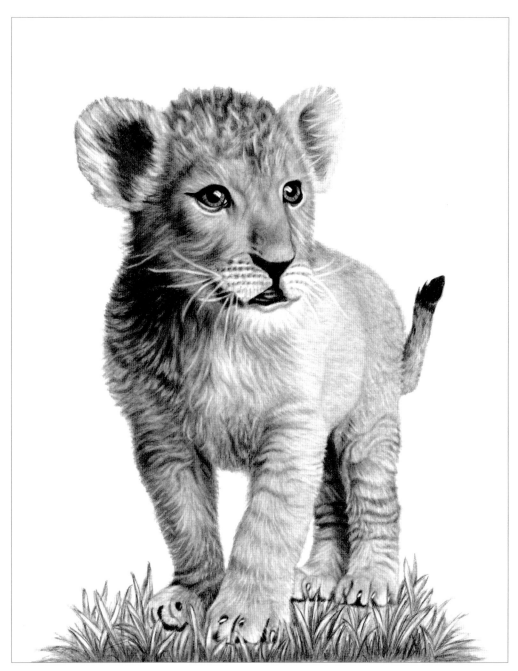

Step 7 I finish the back legs by laying in the dark areas and blending them with a tortillon. Then I lightly add the remaining fur, blend, and pull out individual strands using the edge of my kneaded eraser. I also draw the claws and blend around them. Next I finish the grass by applying loose strokes of graphite, blending, and pulling out highlights with the eraser. To add depth, I darken the ground horizontally from left to right. I finish by touching up a few areas that need to be darkened, lightened, or blended. Then I erase any smudges and spray with workable fixative.

Foal Portrait

When creating a graphite drawing based on a color photo, it is often a good idea to transform the photo to black and white (or grayscale). Removing the distraction of color allows you to clearly discern all the values in the composition. You can transform the photo to black and white using photo-editing software, but a simple and inexpensive method involves using a quality copy machine at a mail or print center.

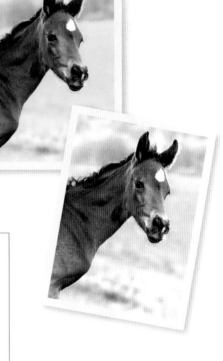

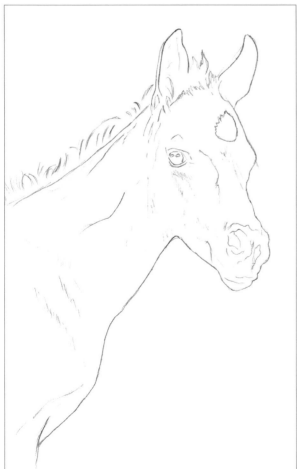

Step 1 I sketch the foal with an HB pencil, placing a few recognizable markings on the face, neck, and shoulders. These guides will help me place my darkest values.

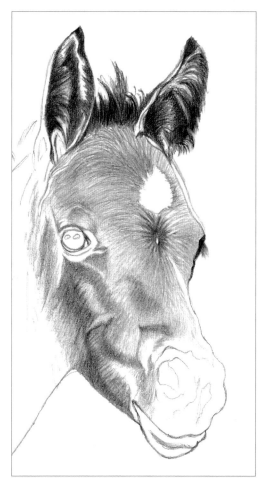

Step 2 I use a 2B pencil to layer hair in and around the ears, beginning at the top and moving down. To create the facial hair, I stroke gently in the direction of hair growth. Notice the extremely curved nature of the hair at the forehead. I begin blocking in the dark areas of hair by layering with firm pressure, but I don't start blending yet.

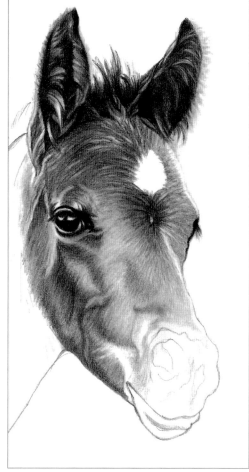

Step 3 Next I return to the ears, building up the dark areas of the ear at right and blending with a tortillon (see "Ear Detail" on page 24). I use the edge of an eraser to pull out curved streaks of hair and blend the midtones. Then I use a dirty tortillon to create short streaks along the outside edge to represent fuzzy, backlit hair. I darken the tuft where needed and recover lights with the eraser. Continuing down the face, I add more lines in the direction of hair growth and blend with my tortillon. I use a 6B pencil for the darkest areas and blend, before I start on the eye (see "Eye Detail" on page 24).

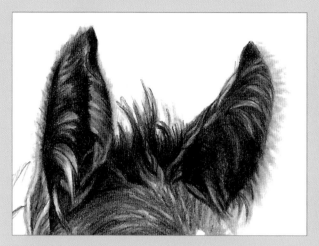

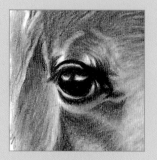

Eye Detail To render the eye, I carefully fill in the pupil and iris with dark tone, working around two white highlights. For the eyeball and surrounding black areas, I lay in two firm layers of 2B graphite.

Ear Detail I develop the left ear in the same manner as the right: blocking in and blending the darks, stroking in hair, blending the midtones, and pulling out lights with an eraser.

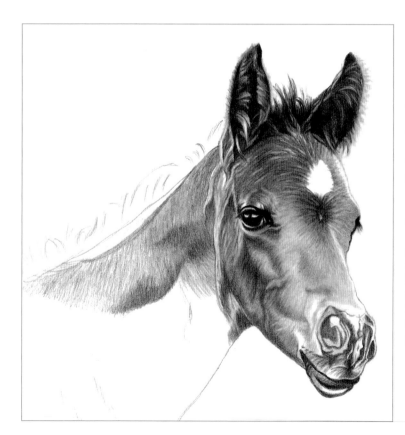

Step 4 I begin the muzzle by blocking in the dark areas with a 2B pencil. I keep one finger on the photo and follow the intricate patterns as I render the nose and mouth. For now, placement of value is my only concern. I also choose to begin the coat on the foal's neck. Stroking in the direction of hair growth, I build up the dark areas with additional layers of 2B graphite.

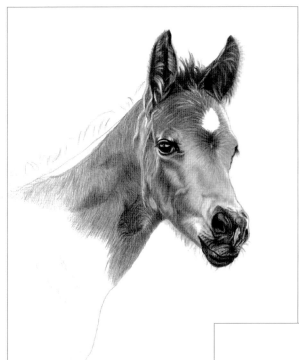

Step 5 I finish the muzzle by drawing over the darkest areas with a sharp 6B pencil and blending with a tortillon. I also blend the midtones and "dirty" the whites. I add whiskers and dots lightly with a 2B pencil and blend them out. My kneaded eraser point is valuable in this step, as I use it to lift graphite in small areas and pull out light streaks. I give the muzzle another light blending to finish. Moving to the neck, I continue to layer hair with curved, directional strokes. For the dark swirl of hair by the jaw, I build density with several layers of graphite.

Step 6 I complete the rest of the foal's body by first layering in hair with short, directional strokes. I apply two to three coats, depending on how dark the hair is, and then blend with a tortillon. Starting at the top of the head and behind the ear, I use a kneaded eraser edge to pull out short streaks of lighter hair throughout, pulling in the direction of hair growth. I blend again with my tortillon to tone down the whites. To finish, I use a 6B pencil to build up density in the darkest areas, including the dark swirl of hair, along the front of the neck, and where the chest meets the upper leg.

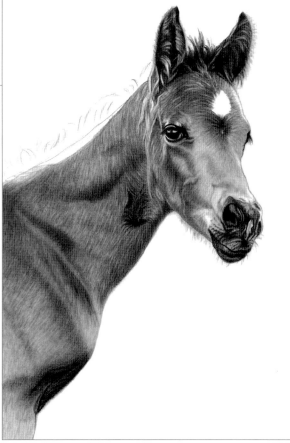

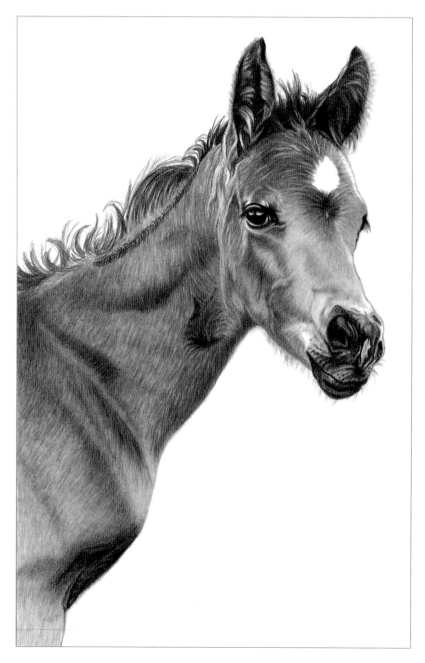

Step 7 I begin the foal's mane at the ear and work my way down the back with a 2B pencil. I keep my strokes loose and free flowing. For the darkest areas, I apply additional layers of graphite.

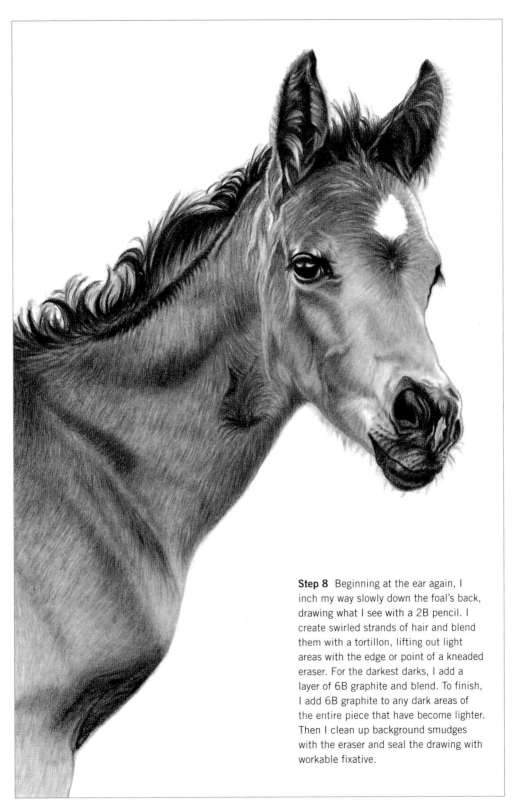

Step 8 Beginning at the ear again, I inch my way slowly down the foal's back, drawing what I see with a 2B pencil. I create swirled strands of hair and blend them with a tortillon, lifting out light areas with the edge or point of a kneaded eraser. For the darkest darks, I add a layer of 6B graphite and blend. To finish, I add 6B graphite to any dark areas of the entire piece that have become lighter. Then I clean up background smudges with the eraser and seal the drawing with workable fixative.

Window Box

In a simple, symmetrical scene like this rustic window, it's important to use contrast to guide a viewer's eye to an area of focus. Contrast refers not only to value but to other elements as well, such as line, shape, and texture. In this scene, the ruffled geraniums stand out against the horizontals and verticals of the surrounding composition and create depth with their side-by-side lights and darks.

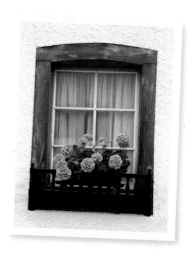

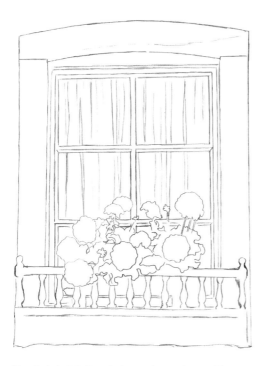

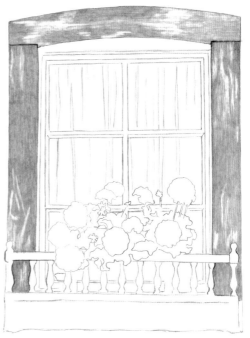

Step 1 I sketch the window and geraniums with an HB pencil. For a realistic look, I draw the lines without a ruler. I may revisit the lines later, if necessary.

Step 2 Beginning with the wooden arch above the window, I apply a light layer of graphite using a 2B pencil. I use light-to-moderate pressure and apply long, horizontal strokes. Although the wood is cut into an arch shape, I keep my lines straight as I follow the grain. I blend with a tortillon and use the edge of a kneaded eraser to lighten areas of the wood based on my reference. I use the same process for the wooden planks on both sides of the window.

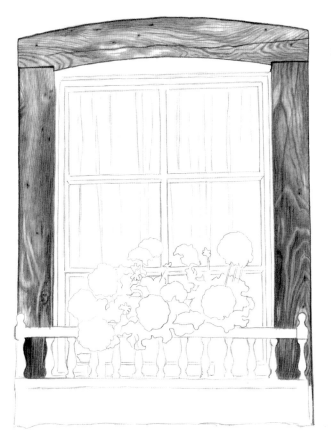

Step 3 Next I draw the wood detail, including grain lines, knots, and nail holes. I begin with the vertical piece at left and move clockwise.

Wood Detail I use my 2B pencil to draw the thin, curved patterns of lines within the wood grain, shading the dark areas and blending with a tortillon. I pull out lighter areas with a kneaded eraser and use dots to suggest nail holes. I complete all three planks in the same manner.

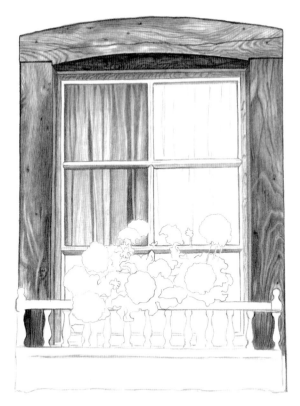

Step 4 With the main frame complete, I finish the rest of the wood and begin the sheer curtains. I coat the shadowed area beneath the top arch with a 2B pencil, using light-to-moderate pressure. Then I blend with a tortillon and add detail. I render the light wood around the window using a 2B pencil and light pressure. I add grain detail and blend to soften. For the grids separating the window panes, I leave the top sections white and shade the undersides with a 2B pencil and a tortillon. For the sheer curtains, I lightly draw the folds and then darken the vertical shadows with 2B graphite and moderate-to-heavy pressure, blending with a tortillon.

Step 5 I continue rendering the sheers by penciling in folds, adding shadows, blending with a tortillon, and then using the edge of a kneaded eraser to lighten where necessary. When complete, I use a ruler to re-line the railings and bottom edge of the window. Then I draw the wooden spindles from left to right and shade them with a 2B pencil. I also apply two layers of 2B graphite over the railing and wood at the bottom of the window. I use horizontal strokes and heavy pressure for both layers.

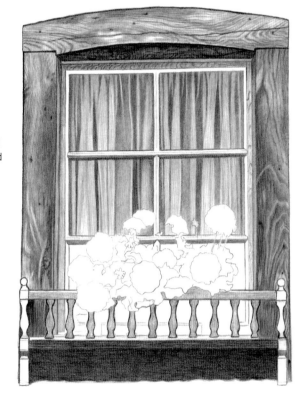

Step 6 Moving from left to right, I finish shading each spindle and add the wood behind the railing. I complete this with a 2B pencil, applying more pressure for the darker wood. Next I outline the flower box and fill it in with 2B graphite, using 6B for the dark bottom. I use heavy pressure and horizontal strokes. To complete the wood and sheers behind the railing, I use the 2B and blend with the tortillon. I also add graphite to areas that have lightened over the course of the drawing.

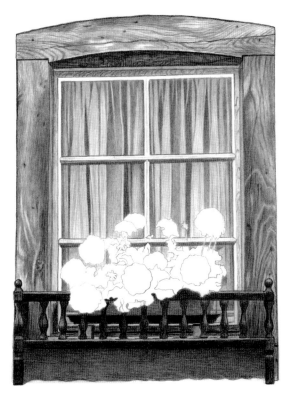

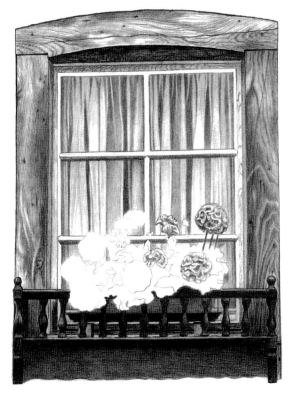

Step 7 I begin rendering the flowers, which will stand out as soft and delicate against the lines of the window and curtains. Beginning with the geraniums at right, I block in the darkest shapes, blend, and draw around the curved areas of light color. (See "Flower and Greenery Detail" on page 32.)

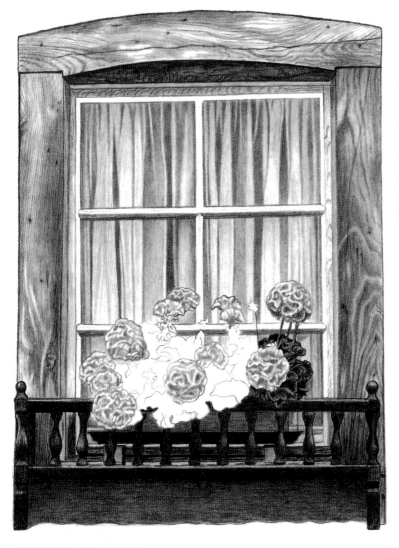

Step 8 I continue to render the geraniums by blocking in the darkest shapes, outlining the lightly curved areas, and blending. I use my kneaded eraser point to lift overly dense graphite. With the geraniums complete, I address the greenery behind the flowers. (See "Flower and Greenery Detail" below.)

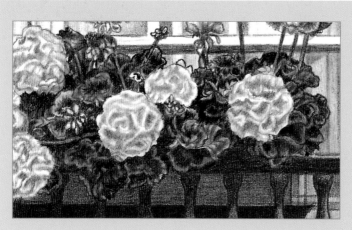

Flower and Greenery Detail I define the flower petals using approximate shapes and outlines. I outline the basic shapes of the leaves and block in the darkest areas with a 2B and firm pressure, shifting to moderate pressure for the lighter green areas.

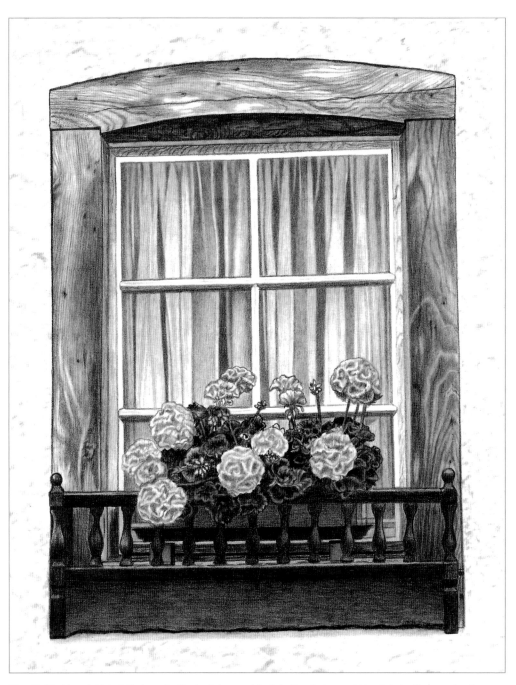

Step 9 Working right to left, I create the leaf shapes, block in the darks, and blend. I don't worry about copying the reference exactly; my goal is to capture the essence of dark leaves to offset the light flowers. I allow my shapes to become more abstract as I progress. I emphasize extreme lights and darks in the flowers and leaves, keeping a few small buds very light. After completing the foliage, I suggest the subtle stucco texture around the window using a "dirty" tortillon and short, random smudges. After a few small finishing touches, I spray the drawing with workable fixative.

Sunflower Still Life

Setting up a still life can be an enjoyable process. Allow your theme to determine the objects and how you place them in the scene. In this composition, a variety of textures spice up a simple floral setup to create an eclectic country theme. The bright, simple shapes of the sunflowers serve as the dominant focus, with the blanket adding detail and contrast. The rustic wood backdrop, chipped table, and unusual vase add interest with soft, mottled textures.

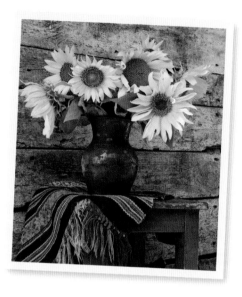

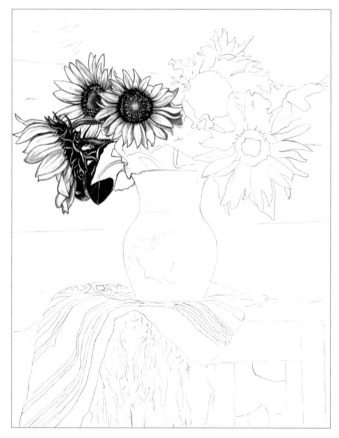

Step 1 I sketch the composition with a sharp HB pencil. Beginning with the sunflower at far left, I re-outline the petal and leaf shapes with a 2B pencil. I focus on values and contrast—not the accuracy of the shapes. I squint my eyes to more easily observe the lights, darks, and midtones. Then I fill in the darks of the sepals and leaves with the sharp point of a 2B pencil, using firm pressure. (See "Flower Center Detail" on page 35.) To create shadows on the petals, I use a slightly "dirty" tortillon with a small point, lightening with the edge of a kneaded eraser. I also use the tortillon to blend the midtones and shadows of the leaves, reclaiming the lights with a kneaded eraser.

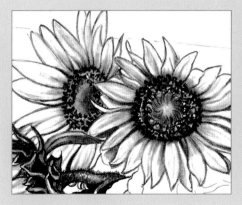

Flower Center Detail For the interior of both sunflowers, I make dark, jagged marks circling the centers while leaving some areas white. I blend the edges of the circular centers into the base of each petal. In the sunflower at right, I sketch swirling lines radiating from the center and blend with a tortillon in a circular motion. I keep the very center of the flower light.

Step 2 For the remaining sunflowers, I erase my initial sketch lines and carefully re-draw each petal as I move clockwise around the flowers. I use a 2B pencil with a light touch. Then I use a "dirty" tortillon to lightly shade some of the petals.

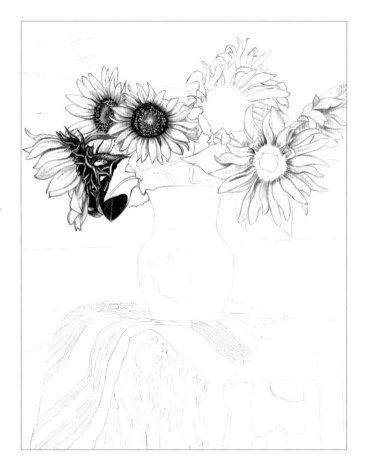

Artist's Tip

I have always had a heavy hand with graphite! If you are like me and need to lighten some areas, such as the sunflower petals, roll a kneaded eraser into a ball and lightly tap the overly dark areas.

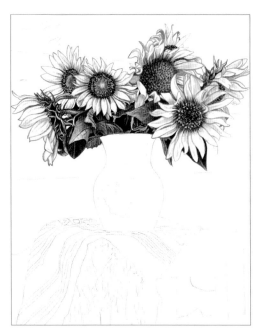

Step 3 Now I complete the centers of the sunflowers with a 2B pencil. For the largest flower in the upper right, I apply small dots in a curved pattern and blend them with a tortillon. Then I darken the left border where the interior meets the petals. For the larger sunflower in the lower right, I draw small white circles around the center. I then darken moderately around them and use heavier pressure in the very center. I add more dark lines and then blend from the center outward into all of the petals. There are two sunflower centers that are barely visible in the photo. For these I dot heavily and blend with a tortillon. Next I move on to the leaves (see "Leaves Detail" below).

Leaves Detail I turn my attention to the leaves and redraw their shapes more precisely. Using a 2B pencil, I shade them based on the values in the photo, using light or heavy pressure as needed. I lightly draw and blend vein lines, and I pull out highlights with the edge of a kneaded eraser.

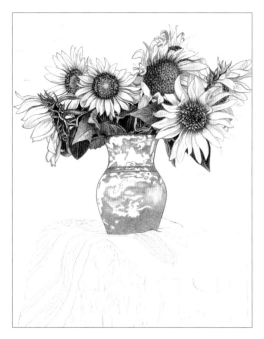

Step 4 Using light strokes and several layers of a 2B pencil, I block in the midtones and darks of the vase. Because the pattern is irregular, I'm not concerned about replicating it exactly; my goal is to create the essence of it.

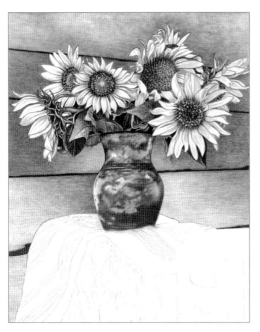

Step 5 Now I work on the darks of the vase and build density by adding two layers of 2B graphite. I then lightly shade the midtones, which are the red areas in the color photo. I leave the lightest reflections white and use a tortillon to blend softly around the vase. For the wood background, I lightly shade the boards starting in the top left, stroking in the direction of the grain. I blend these strokes with a tortillon and ignore details at this point, thinking only of darks, midtones, and lights.

Artist's Tip

When converting a color photo to a graphite piece of art, occasionally view your progress in dim lighting. This will help you better see the contrast and highlights in the piece.

Step 6 Now I bring the wood to life. Beginning at the top and moving downward, I complete each board by suggesting wood grain, paint chips, and nail holes. My goal is to capture the general appearance of each board. (See "Wood Detail" on page 38.) Because the vase is dark, I keep the wood background lighter than in the photo. However, this may change as the overall values evolve.

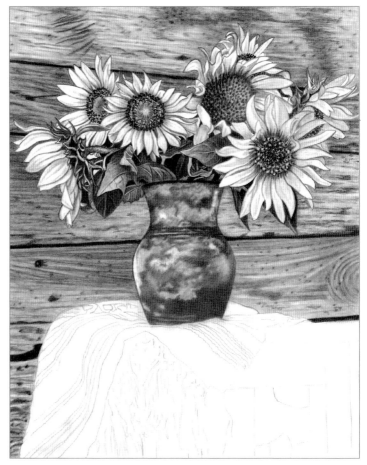

Wood Detail Using a 2B pencil, I stroke in dark lines to establish the pattern of the wood grain. I alternate between a 2B pencil, tortillon, and kneaded eraser. Then I blend with a tortillon and use the straight edge of a kneaded eraser to pull light streaks through the grain. I add dots, irregular marks, wood swirls, and nail holes.

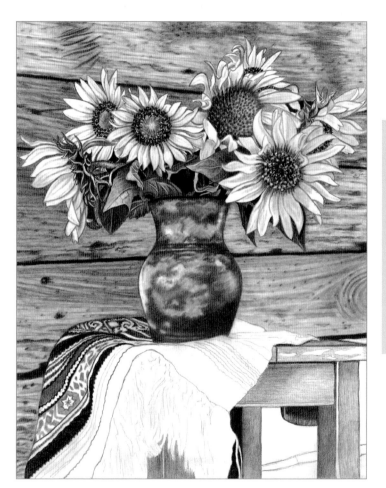

Artist's Tip

When drawing an object with fine details and patterns, don't worry about following the reference photo exactly. Instead, create a drawing that simply resembles the object, taking liberties with values as needed.

Step 7 I start the blanket in the upper left corner adjacent to the vase, re-outlining stripes and patterns. Because the vase, leaves, and wood all project darker values, I make it a point to leave some light—even white—stripes in the blanket for contrast. To balance the darks of the blanket, I darken the vase and leaf shadows with a 6B pencil. Then I move on to the table and delineate white shapes to represent chips along the edge. I apply a layer of 2B graphite to the rest of the table using moderate pressure, followed by a firmer layer in the shadowed areas.

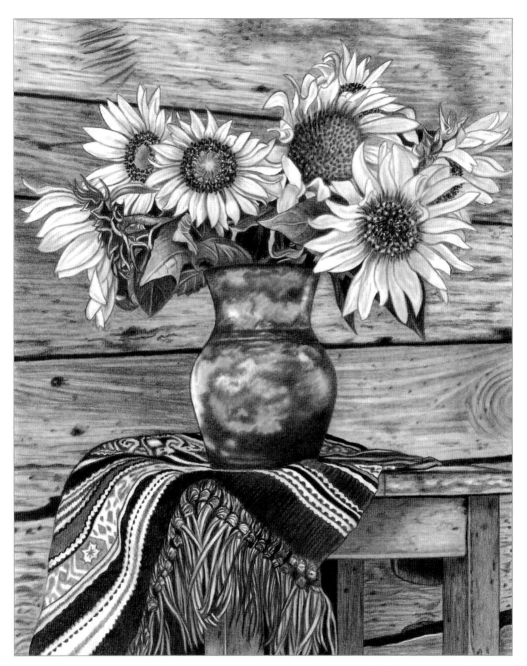

Step 8 Using a 2B pencil and moving counterclockwise, I complete the simplified blanket pattern. Next I tackle the fringe, starting with the knots and then lightly stroking in overlapping threads. I keep the strands light in the center to suggest the cylindrical nature of the fringe, and I add shadows using firm pressure and a 2B pencil. For the table, I layer graphite over the wood in the direction of the grain, adding irregular markings and blending with a tortillon. I complete the wood boards beneath the table using my process from steps 6 and 7. With the wood complete, I turn my eye to the overall composition and darken a few areas where needed. I erase all smudges and spray with workable fixative.

Bike & Barn

Detail is the hallmark of an artist who specializes in traditional realism. Viewers enjoy visually traveling around a composition and identifying significant elements. This project involves woodwork, bicycle detail, and blades of grass, giving it a great deal of texture. When viewed as a whole, it is a delightful country scene that does not appear too difficult to render—and it really isn't! However, time and patience are required to bring each plank, spoke, and blade to life. If this is a composition that appeals to you, it will be time well spent!

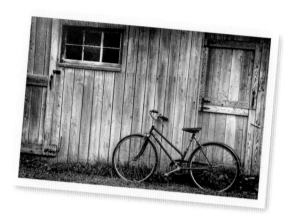

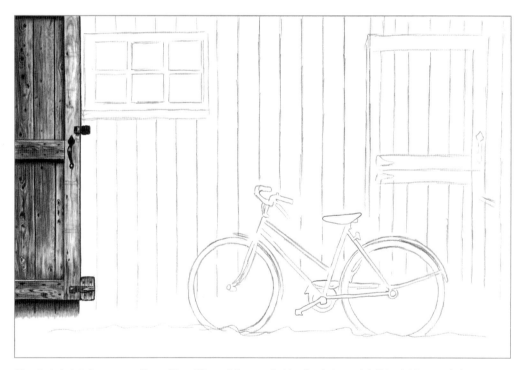

Step 1 I sketch the composition with a 2B graphite pencil. My plan is to work left to right, completing the barn first followed by the bike and grass. Next I complete the boards of the door at left. I tackle each board individually using whisper-light strokes of a 2B pencil to lay a foundation over the area; then I blend with a tortillon. I squint to more easily see my lights and darks, adding more graphite to darker areas where needed and blending with my tortillon. Lastly, I use a sharp 2B point to draw the wood details and dark lines between the boards (see "Door Detail" on page 41). If my graphite becomes too heavy, I form a kneaded eraser into an edge and pull it through the graphite to lift away tone.

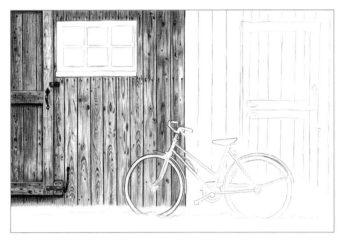

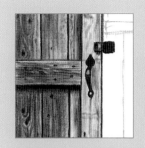

Door Detail I detail the door by adding wood knots, small black holes, and grain lines. I model the handle and hinges using a 2B pencil with heavy pressure.

Step 2 I continue rendering each board from left to right: I apply and blend an initial light layer of tone; then I darken where necessary and blend again. I use a rubber eraser to lighten where needed. I lay in the dark details, such as grain patterns, the door chain, and nail holes. When I need to lighten, I roll my kneaded eraser into a ball and gently blot to lift graphite. Lastly, I redraw the lines separating the boards using firm pressure and a sharp point.

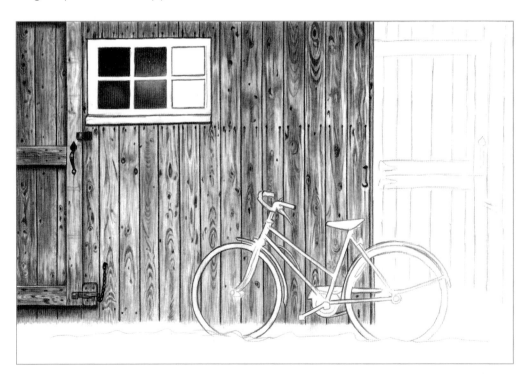

Step 3 I finish the remaining barn boards up to the large doorframe and turn my attention to the upper left window, using a straight edge. The values so far have been midtones, so it's time to add contrast. I develop the window panes using a 5B graphite pencil, adding a light layer of tone, and then building density around the lighter areas, blending with a tortillon. I add more graphite to the dark areas and blend down the lighter areas until satisfied.

41

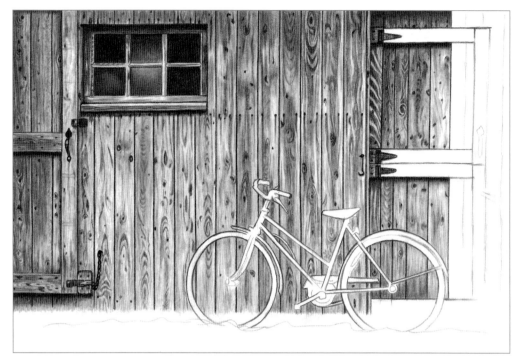

Step 4 I finish the window panes using a 5B pencil, tortillon, and rounded kneaded eraser, which I use to pull up graphite from overly dark areas (see "Window Detail" below). Next I move to the door at right. I render each wooden plank in the same manner as the other barn planks, moving methodically from left to right. I begin the hinges using my 5B pencil.

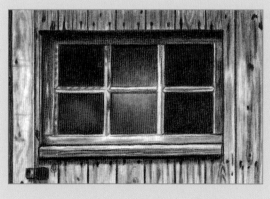

Window Detail Notice that the panes at far right are the darkest and show no reflections of light. I proceed to the window frame and squint to determine the darks and lights. I use a 5B pencil for the darkest darks of the area—the shadows along the top edge and beneath the ledge of the window. I draw the remaining shapes and lines with a 2B pencil and blend with my tortillon. To pull out streaks of lighter wood, I use the edge of my kneaded eraser.

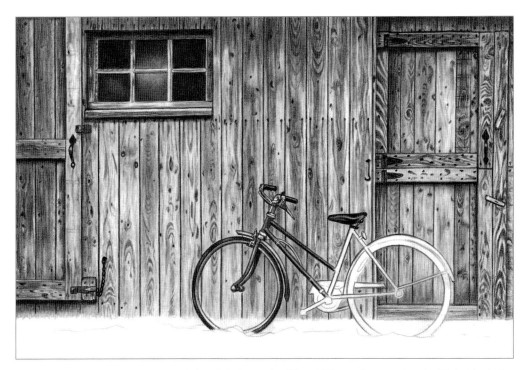

Step 5 I complete the door and remainder of the barn with 2B and 5B pencils, reserving the 5B for the darker areas. As I look over the entire barn, I decide to enhance the contrast by darkening the values of the door at left, the area above the window, and the middle planks. This balances out the lights and darks of the barn across the composition. Then I begin working on the bicycle (see "Bicycle Detail" below).

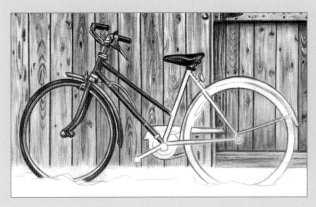

Bicycle Detail I begin lining in the bicycle using an HB pencil, moving from left to right. HB lead is slightly harder than 2B lead and provides a sharper point for the bicycle details. Where extreme darks are needed, I use my 5B pencil with a sharp point. To erase, I form a kneaded eraser into a point and either dab or drag over the area. I use a tortillon with a small point for blending.

Artist's Tip

If your tortillon point becomes blunt, straighten out a paper clip and insert it into the hollow tortillon. This will push out the tip to restore a sharp point.

Step 6 I finish the bike using my HB pencil for detail and 5B pencil for extreme darks. I blend with my tortillon and use the point of my kneaded eraser to pull out lights. I develop the grass behind the wheels before starting on the spokes. To begin, I erase my initial sketch line across the foreground. Beginning on the left side, I lightly draw random blades of grass.

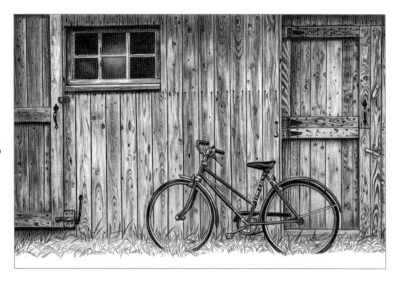

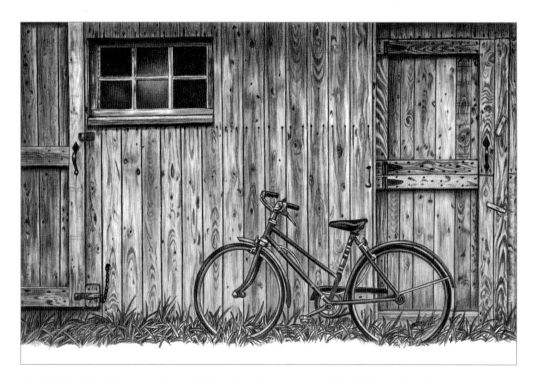

Step 7 After I finish the grass, I use a 2B to darken the areas around the blades, adding depth. I then use my tortillon to blend the grass.

Artist's Tip

While doing your best to create a realistic bike, don't be overly concerned about extreme detail. Most people will immediately know what the subject is and appreciate any hints at detail you include.

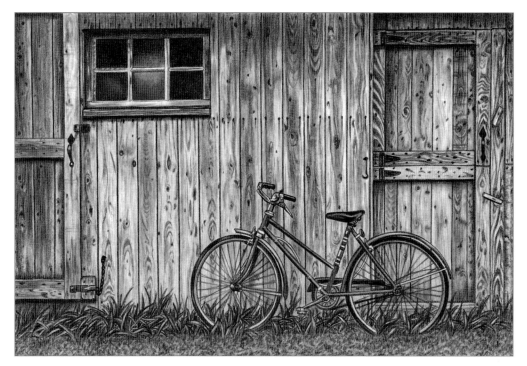

Step 8 I complete the grass and detail the wheel spokes (see details below). I add a few final touches of graphite where needed. This step is often necessary at the end of a project that includes dark, soft lead because some graphite inevitably transfers onto the protective white paper between my hand and the original. I erase all smudges and spray with workable fixative.

Grass Detail To finish this dense area of grass, I darken with a 5B for a dramatic contrast to the lighter barn. I blend again with my tortillon and pull out a few highlights with the edge of my kneaded eraser. The short foreground grass is easy to render. I simply draw connected, random squiggles with my 5B pencil and blend everything together with my tortillon.

Wheel Detail To complete the wheel spokes, I use a sharp HB point to follow the photo carefully. I forego highlighting some of the spokes—my eraser is not thin enough to re-create these. Instead, I make some spokes lighter than others.

Dog Portrait

Graphite artists can choose from a variety of leads. I tend to choose dark, soft leads that help me create contrast and drama in my compositions. In some cases, however, extreme darks may not be appropriate. This lesson features a portrait of Peaches—a lab mix with a loving disposition. Because Peaches is a white dog, I choose to keep everything fairly soft, including the shadows. I also eliminate the dark background in the photo and make the edges of fur subtle and blurred, allowing the viewer to focus on Peaches.

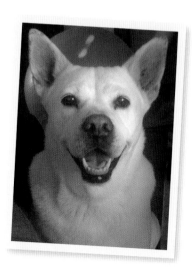

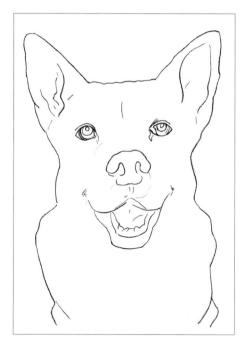

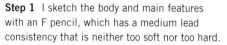

Step 1 I sketch the body and main features with an F pencil, which has a medium lead consistency that is neither too soft nor too hard.

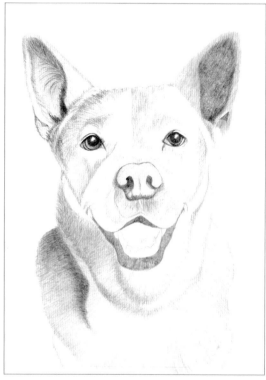

Step 2 I use a 2B pencil to stroke in an initial layer for the dog's coat, beginning with the ears and moving downward. I apply several layers of graphite to the darkest areas and block in the shapes of the eyes.

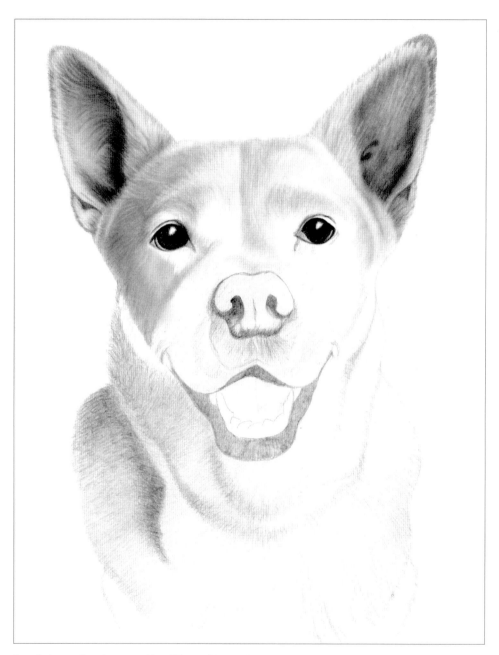

Step 3 I complete the ears with a 2B pencil by adding more layers of graphite to the darkest areas, blending them with a tortillon and then lightening them with a kneaded eraser shaped into a point. I draw individual strands of hair, blend, and lighten. Now that I have excess graphite on my tortillon, I can use it as a drawing tool. I continue pulling out highlights with the eraser and then gently blend large areas with a chamois for a smooth appearance. I also refine the eyes by darkening the pupil and iris in each, preserving the white highlights by drawing around them.

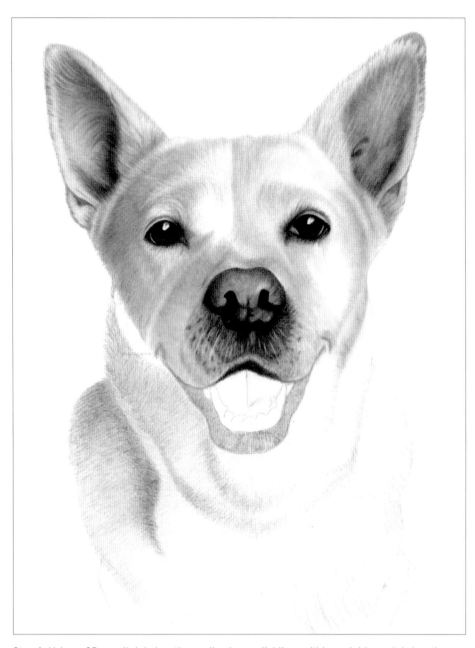

Step 4 Using a 2B pencil, I darken the pupils, draw radial lines within each iris, and darken the rims. I blend the eyebrows and markings around the eyes with a tortillon. Then I re-outline the basic shape of the nose and fill in the darkest areas. I use my tortillon to blend and my eraser to lighten. I carry over this process to the muzzle area, where I add the darks, blend them down, and pull out whiskers with a molded eraser point.

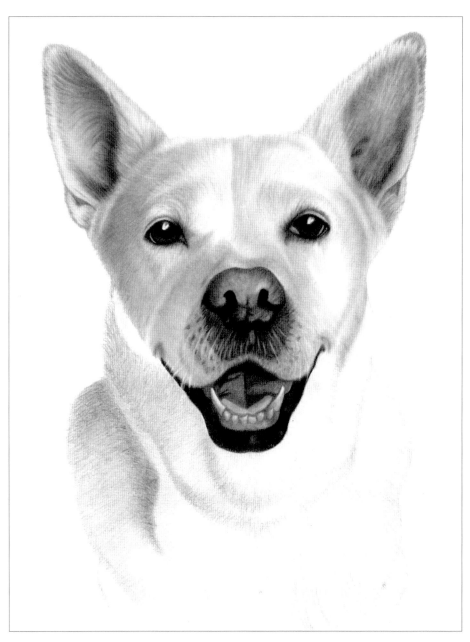

Step 5 For this step, I concentrate on completing the mouth by blocking in the extreme darks with layers of 2B graphite. I lightly fill in the tongue, blend, and build up the midtones with the graphite on the tortillon. I keep the tongue soft by blending, and I outline the teeth and gums. I pull out a few whiskers with my kneaded eraser molded into a thin edge. I refine the muzzle and add a bit more dark to the area. Then I place curved smile lines at the upper corners using my tortillon.

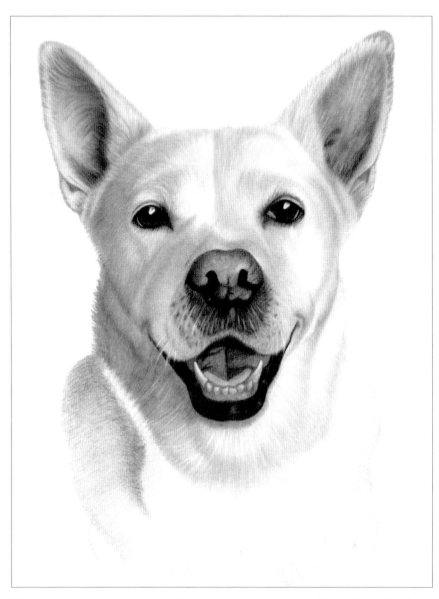

Step 6 Next I apply a layer of graphite over the dog, moving from left to right. On the left side of the dog, I use a "dirty" tortillon to apply the graphite and then use the kneaded eraser to pull out light streaks. I continue blending until the coat matches my reference. On the right side, I use the "dirty" tortillon to blend the coat and pull out light hairs.

Artist's Tip

When an area is too dark and needs to be lightened softly, form your kneaded eraser into a small ball and dab it several times across the area using gentle pressure. This will lighten the area evenly without streaks.

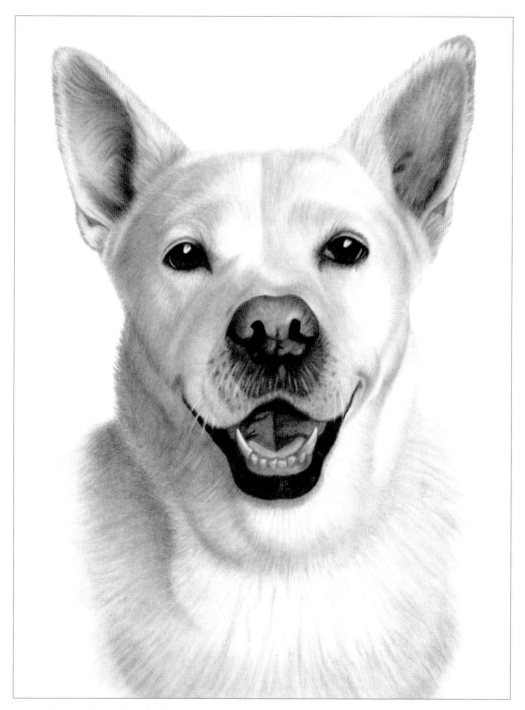

Step 7 In the last step, I render the coat over the chest. I lay down a light layer of graphite with a 2B pencil and blend the shadow areas until they are smooth. Using a dirty tortillon, I create lighter fur in the center and right side. To do this, I blend the areas using the tortillon, stroke individual strands in the direction of hair growth, and then blend outward with a chamois cloth. I repeat this process several times. To finish, I blend and blur the edges of the coat outward into the white paper. I take a moment to make any final small changes, and then I spray the drawing with workable fixative.

Sports Car

Reflections on automobiles can be complicated to render. The car's body, windshield, and side windows are all affected by the lighting and surrounding elements, and the busy reflections can distract viewers from the shiny, smooth quality of a car's surface. In this drawing, my goal is to simplify the reflections and demonstrate how to create believable automobile compositions in any outdoor lighting condition.

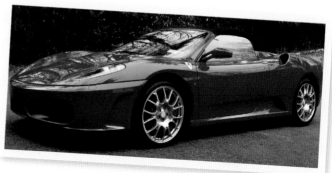

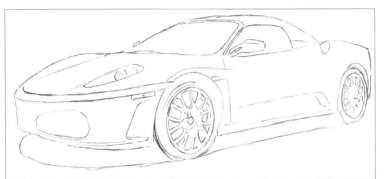

Step 1 I sketch the shape of the car and cast shadow with an HB pencil, paying particular attention to the wheel detail. As I complete each section, I refine the existing lines and edges.

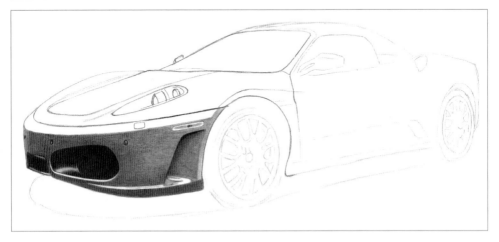

Step 2 I erase, lighten, and refine some of the sketch lines, working around shadows and reflections. With a 2B pencil, I lightly layer the bottom half of the car's front end. I keep my strokes light, smooth, and consistent as I work from left to right and build up layers of graphite. I use a tortillon with a small point to blend everything, leaving the reflections and highlights white. To complete the darkest areas, I apply several coats of 6B pencil, using medium pressure and a sharp point. (See "Front End Detail," on page 53.) I use a 2B pencil to draw the small circles and elliptical details.

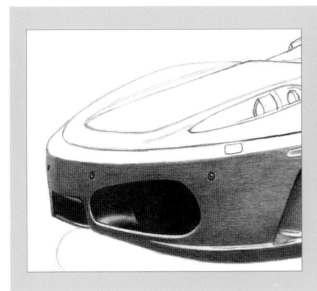

Front End Detail To achieve maximum density in black areas, I change the direction of my strokes for each layer. I also brush away pencil crumbs frequently with my drafting brush and lightly tap a kneaded eraser to pick up excess graphite. To clean up highlights and reflection shapes, I form the eraser into an edge.

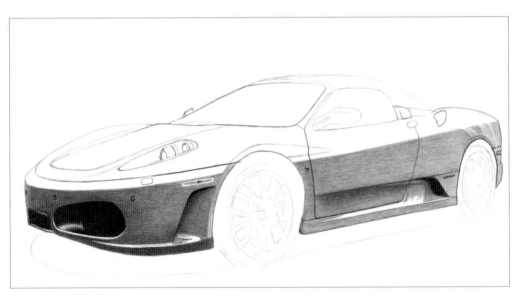

Step 3 I move to the right of the front wheel and redraw the lines of the body, which extend to the back end. With whisper-light strokes and continuous coverage, I layer four soft coats of 2B graphite across the side of the car and blend with a tortillon. I then build up the darker shadow areas in the lower half with my 2B pencil, followed by blending. I repeat this process until I am satisfied with the contrast. I use my kneaded eraser to lift smudges and create highlights and reflections. Then I draw and lightly blend small details.

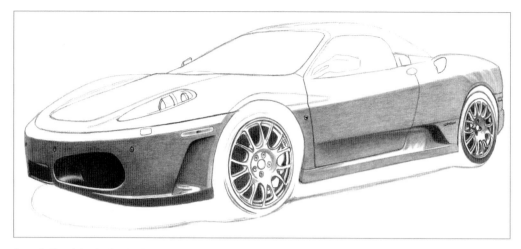

Step 4 Next I begin developing the wheels (see "Wheel Detail 1" on page 55). They will be the focal points of the drawing. As such, it's important to take your time rendering the hubcaps and tire treads. The more realistic the wheels look, the better the drawing will be.

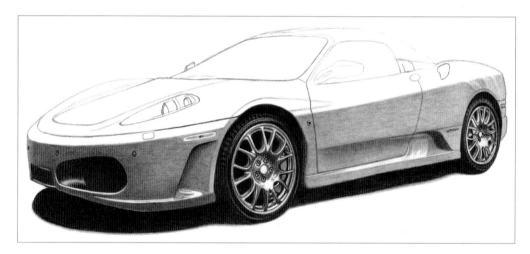

Step 5 This step requires the most patience. I spend a lot of time capturing the wheels' elliptical lines accurately to create convincing perspective. Then I complete the hubcaps one section at a time (see "Wheel Detail 2" on page 55). Once I complete the hubcaps, tires, and interior areas of black, I use a 6B pencil to create the dark shadow under the car. I blend the edges with my tortillon for a slightly blurred effect.

Artist's Tip

Graphite can be messy, especially soft, dark leads like 5B, 6B, and so on. It's a good idea to keep your rubber eraser handy and erase smudges often to prevent buildup on the white areas of your clean surface.

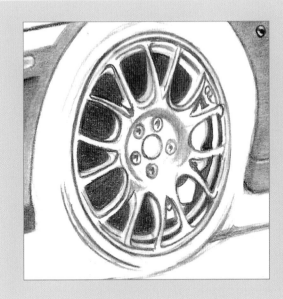

Wheel Detail 1 I begin by re-lining the front hubcap with an H pencil. This lead is harder than the 2B and has a sharper point. I move clockwise and draw exactly what I see, adding some basic shading. I follow the same process for the back hubcap.

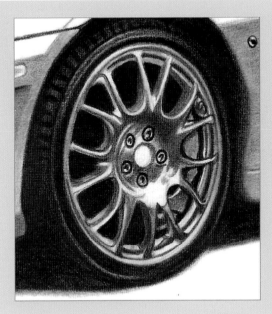

Wheel Detail 2 For the black areas of the wheels and tires, I apply 2B lead followed by 6B. For the extreme darks, I again cover with 6B lead. I keep the lightest areas white and use the edge of my kneaded eraser to reclaim the white of the paper when necessary. I use a 2B pencil and tortillon to create the midtones. To represent the tread, I add stripes along the tops of the tires.

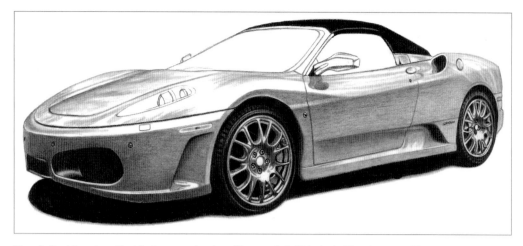

Step 6 Next I work on the black canvas top (see "Canvas Detail" below). Then I use an HB pencil to draw the body details below the canvas and toward the rear, darkening areas with my 2B pencil. To create soft streaks across the upper body, I use a "dirty" tortillon and a kneaded eraser. I supplement with 2B lead where needed and blend. I add more 2B to the entire side of the body, and I draw the sloping triangle above the front tire with the 2B. I also use the 2B to sketch the side-view mirror and its shadow. Then I develop the hood (see "Hood Detail" below).

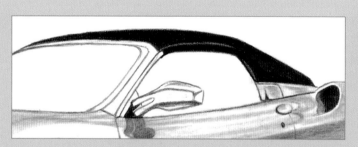

Canvas Detail The extremely dark values above and below the car serve to sandwich the highlights and midtones. All three values must be present to achieve a pleasing composition. I use a 6B pencil to lay in the black canvas top and the black vent at the far right.

Hood Detail I choose to deviate from the photo for a simpler blend of reflections on the hood. I use a dirty tortillon and a 2B pencil to lay in some tone and blend. I emphasize the dark lines of the hood with strokes of the 2B.

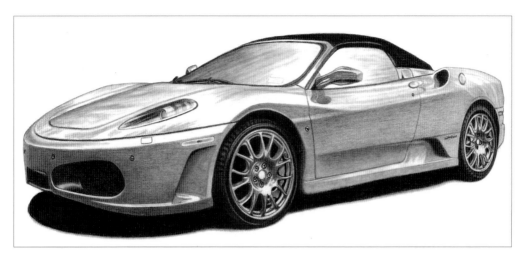

Step 7 Now I move on to the front headlight. I use an HB pencil to define the lines and lightly fill in the area with tone. I follow this by softly shading the cylinders. I then draw the dark streaks, blend, and use my kneaded eraser to pull out light streaks. I complete the windshield (see "Windshield Detail" below) and then finish both side-view mirrors using 2B graphite, a tortillon, and a kneaded eraser. After using the eraser to remove any smudges from the drawing, I use a 6B pencil to bring out the darkest areas. Finally, I spray the drawing with workable fixative.

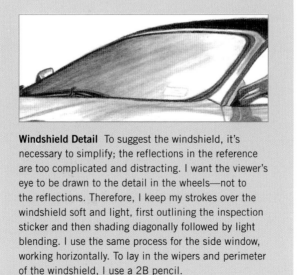

Windshield Detail To suggest the windshield, it's necessary to simplify; the reflections in the reference are too complicated and distracting. I want the viewer's eye to be drawn to the detail in the wheels—not to the reflections. Therefore, I keep my strokes over the windshield soft and light, first outlining the inspection sticker and then shading diagonally followed by light blending. I use the same process for the side window, working horizontally. To lay in the wipers and perimeter of the windshield, I use a 2B pencil.

Vintage Carriage

Negative space refers to the areas around your object of focus. When working with a white object, such as this carriage, negative space plays an important role in defining the object and creating interest within the scene. As you work around the white areas of your subject, such as the wheel spokes, keep an eraser on hand so you can frequently remove smudges. The goal is to keep the white of the paper free from tone for a crisp, clean presentation.

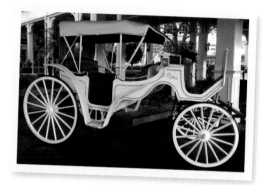

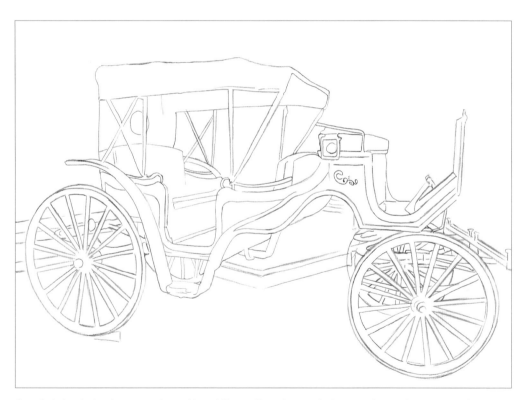

Step 1 I sketch the vintage carriage with an HB pencil, paying particular attention to the accuracy of the wheels and spokes. Once rendered, these elements must be properly aligned or the entire composition will look sloppy.

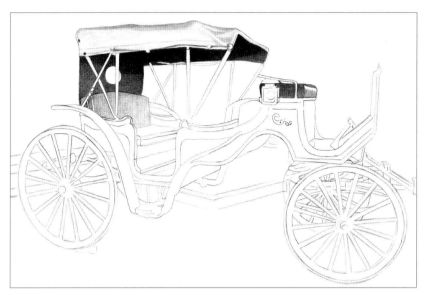

Step 2 I layer the canvas top with 2B graphite, adding more layers to the shadow along the top. I blend with my tortillon and lightly add the line of stitching from left to right. For the shadowed underside of the canopy, I layer 2B pencil with firm pressure and add another coat over the darkest areas, using a tortillon to blend. Next I begin the leather interior with the 2B pencil, using light pressure and vertical strokes. I add a second layer over the driver's seat and leave the highlight white. I fine tune the area by adding poles and lines to the passenger seat.

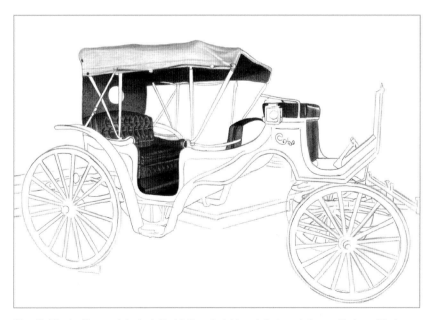

Step 3 The leather seat looks intimidating, but I break it down into small steps. First, I draw the horizontal lines at the proper distances from each other. Then I begin the carriage floor and work my way up, filling in one section at a time with 2B graphite. The floor is very dark, so I apply more pressure as I stroke. Then I move on to the seat cushion (see "Seat Detail" on page 60).

Seat Detail For the cushion, I work from left to right. I first draw the curved indentations and focus on how the shapes relate to one other. I draw each shape, add more graphite around it, blend the graphite, and refine the contours until it reflects the reference. I use a tortillon and kneaded eraser to tweak the values and add more graphite to darken the heavily shadowed areas. I complete the remaining leather pieces in the same way.

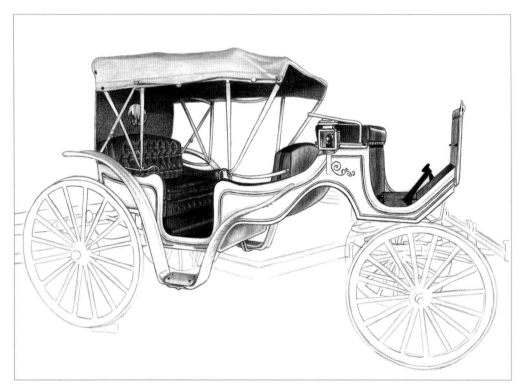

Step 4 In this step, I render the body of the carriage, including the poles and exterior details. To create the poles, I lightly outline them and shade them with the point of a "dirty" tortillon. (I may choose to lighten them later with my kneaded eraser.) Then I redraw the decorative lines and designs on the body. I use a 2B to render the driver area and interior cushion, blending with a tortillon. I also use 2B for the side fender unit and underside of the carriage. I detail the round mirror and square lamp, and I use the edge of a kneaded eraser to pull out highlights.

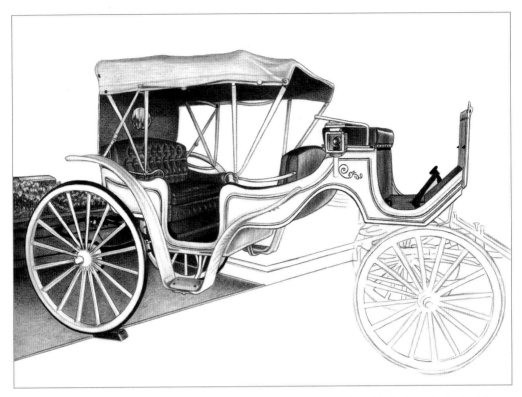

Step 5 I turn my attention to the wheels and wooden attachments, beginning with the large back wheel (see "Wheel Detail" below). I use my eraser to keep each spoke clean and white. Then I render the background that is visible through the spokes, including the flowers, wood, and flooring. I work from left to right and use a 2B with varying pressure to create the different values.

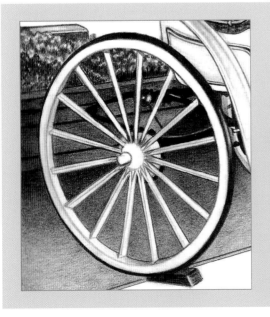

Wheel Detail I outline the rubber tire and fill it in with 2B graphite and firm pressure. Then I outline each spoke and create the hub details.

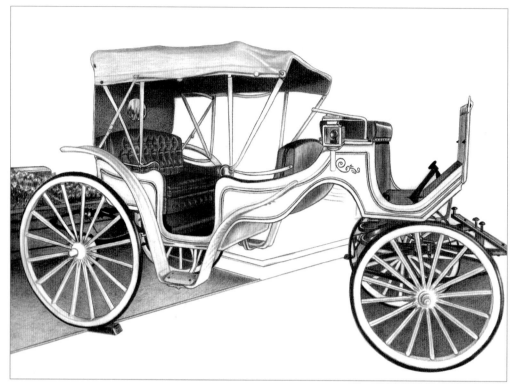

Step 6 Now I focus on the front two wheels and harness. First I outline each spoke of the large front wheel and lightly add a midline to each. I shadow the center hub with a "dirty" tortillon. Beginning at the nine o'clock position on the front wheel and moving clockwise, I fill in the triangular negative spaces between each spoke, which includes the harness and the distant wheel. It is important that each section relates realistically to the others. For the lower half of the wheel, I simply shade the sections with 2B to represent the flooring.

Artist's Tip

The wheels are dominant in this composition. Do your best to keep them as round as possible. Also, the spokes and rims must remain white and free of smudges. Be sure to keep a clean sheet of paper beneath your hand as you draw, and use your eraser frequently.

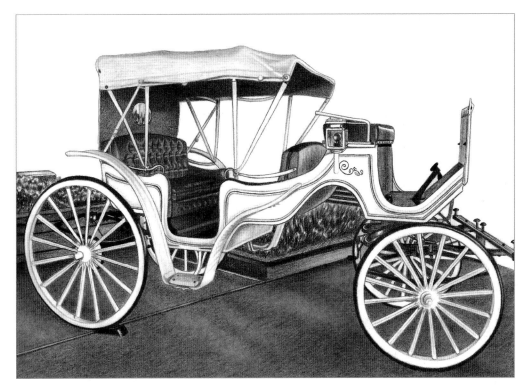

Step 7 I finish the flooring by laying down 2B graphite, using moderate pressure and stroking in the same direction as the mid-floor line (see "Flooring Detail" below). Next I render the center island of foliage bordered by wood (see "Foliage Detail" below). Then I draw the slats of a bench just above the foliage and blend. To finish, I erase smudges and spray the drawing with workable fixative.

Flooring Detail To create the subtle shadows across the floor, I apply a layer of 6B over the initial layer of 2B graphite, stroking in the same diagonal direction as the seam in the flooring. I blend everything with a tortillon for a smooth finish.

Foliage Detail I coat the wooden island with several light layers of 2B graphite, adding more layers with firm pressure for the dark areas. I scribble in random patches for the foliage, connecting, darkening, and blending them as I see fit.

Closing Thoughts

Once you've learned and practiced even a small set of techniques, there is no limit to what you can draw in pencil. I have always enjoyed taking my camera out into the field and looking for interesting subjects to draw. In this digital age, it doesn't matter if you take 100 photos and 99 are bad. Just delete them. Print the one picture you like, place it on your drawing board, and turn it into a masterpiece!

Beautiful graphite works are found in museums, galleries, and private collections. There is a purity to artwork created in a black-and-white medium; its appealing simplicity softens the edges of life in a chaotic world. The color is not there to distract us, allowing us to appreciate the qualities of line, shading, and detail.

I encourage you to continue down your artistic path by experimenting with different pencils and papers and developing your own style. Look through books and art magazines and find what appeals to you. Join up with a few folks who share your passion for drawing, and challenge each other to create new and different artwork. Most importantly, enjoy the process and continue to seek out new subjects that inspire you to become the very best artist you can be!

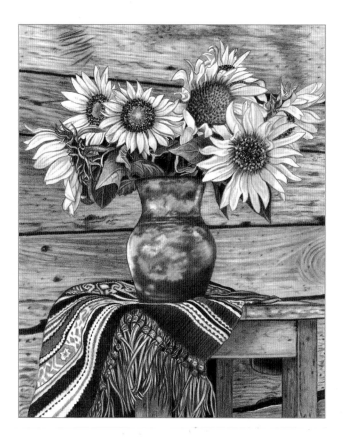